How to Draw
Horses

In Simple Steps

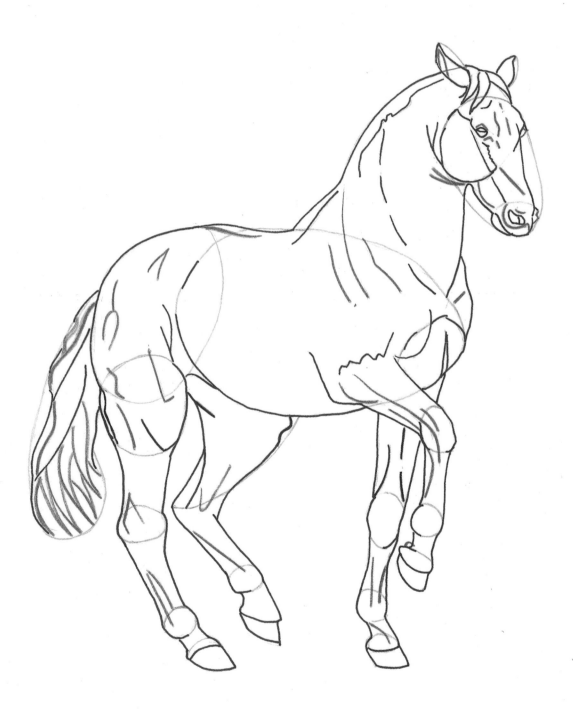

First published in Great Britain 2009

Search Press Limited
Wellwood, North Farm Road,
Tunbridge Wells, Kent TN2 3DR

Reprinted 2010 (twice), 2011, 2013 (twice), 2014,
2015 (twice), 2017 (third), 2018, 2019

Text copyright © Eva Dutton 2009

Design and illustrations copyright © Search Press Ltd. 2009

ISBN: 978-1-84448-372-3

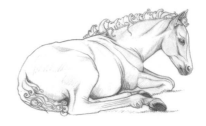

Dedication

*To the horses I have ridden and worked
alongside, thank you for showing me
your curiosity and joy in life.*

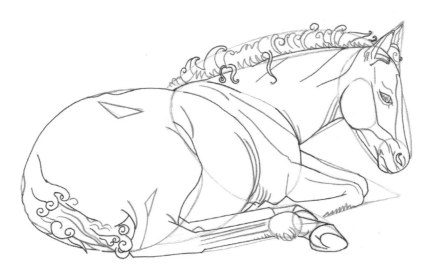

Illustrations

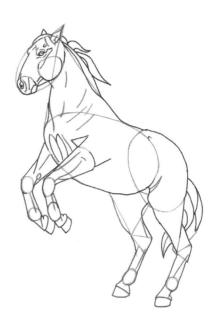

How to Draw
Horses

In Simple Steps
Eva Dutton

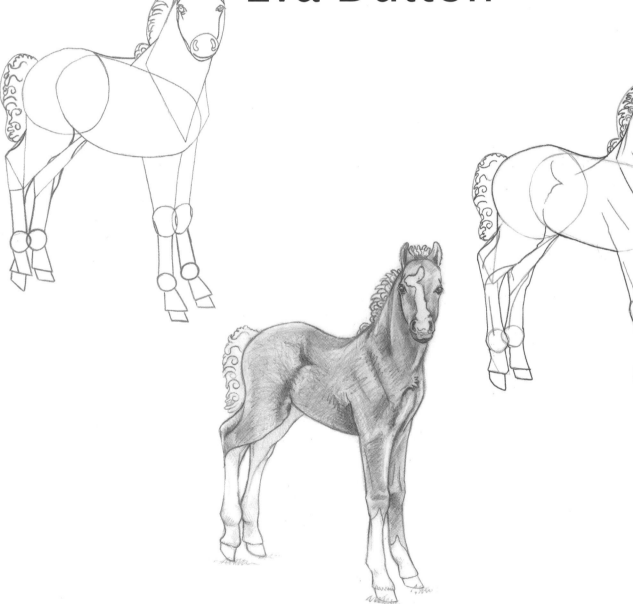
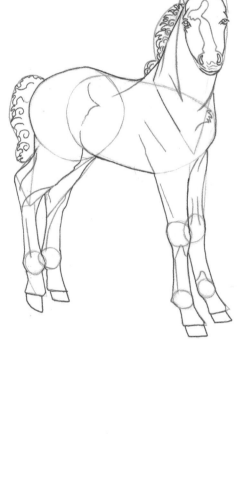

Search Press

Introduction

Horses and ponies galore! I hope that this book will inspire you and act as a starting point to help you develop an understanding of the subjects and an ability to capture their characters.

I have included a broad range of horses in both static and dynamic positions from rolling to rearing and from standing to galloping. Different breeds are included, with varying colours and markings, to give you an idea of the wonderful variety that exists in the equine world. To gain further knowledge, look at the very best equestrian artists: George Stubbs' anatomical studies; Leonardo da Vinci, whose horse sketches and lines show such power and freedom of movement; and Lucy Kemp Walsh, for the expression and sensitivity for her subject. Also, look at sculptures and the work of Henry Moore for example. This will teach you about the form, energy and essence of horses.

In this book, I use a series of simple shapes to demonstrate how to draw a horse's structure, proportions and basic anatomical detail. Each sequence begins with pencil drawn shapes. New lines are added for each subsequent stage and I have drawn these in a terracotta coloured pencil crayon for clarity, with the previous pencil lines left in as a guide. As the terracotta lines are difficult to erase, you should continue to use pencil when you are copying the stages.

The fifth stage tonal drawing is a development of the horse's shape and any markings, with unwanted pencil lines erased. On the final drawing I use a black fine-tipped pen to ink in the lines I want to keep and erase any further unwanted pencil lines. The volume and markings of the horse are developed in this final image and I use watercolour to indicate the colours of each animal. If you want to develop your drawing in this way, you should choose a medium that you enjoy using.

Finally, if you want to develop your drawing skills, the best advice I can give you is to observe from life. While photographs can be a useful reference guide and can inspire you to draw different subjects, they cannot replace direct drawing from a living, breathing animal. Local horse shows are great places for observing movements and postures. In-hand classes are especially good, as you can view the horses without their riders. Understanding the anatomy of the horse is important, so do learn about the underlying structure of this animal and your drawing skills will really start to improve. Mistakes are how you learn, so if you do find you are going wrong, just start again. It is all part of the learning process.

Happy drawing!

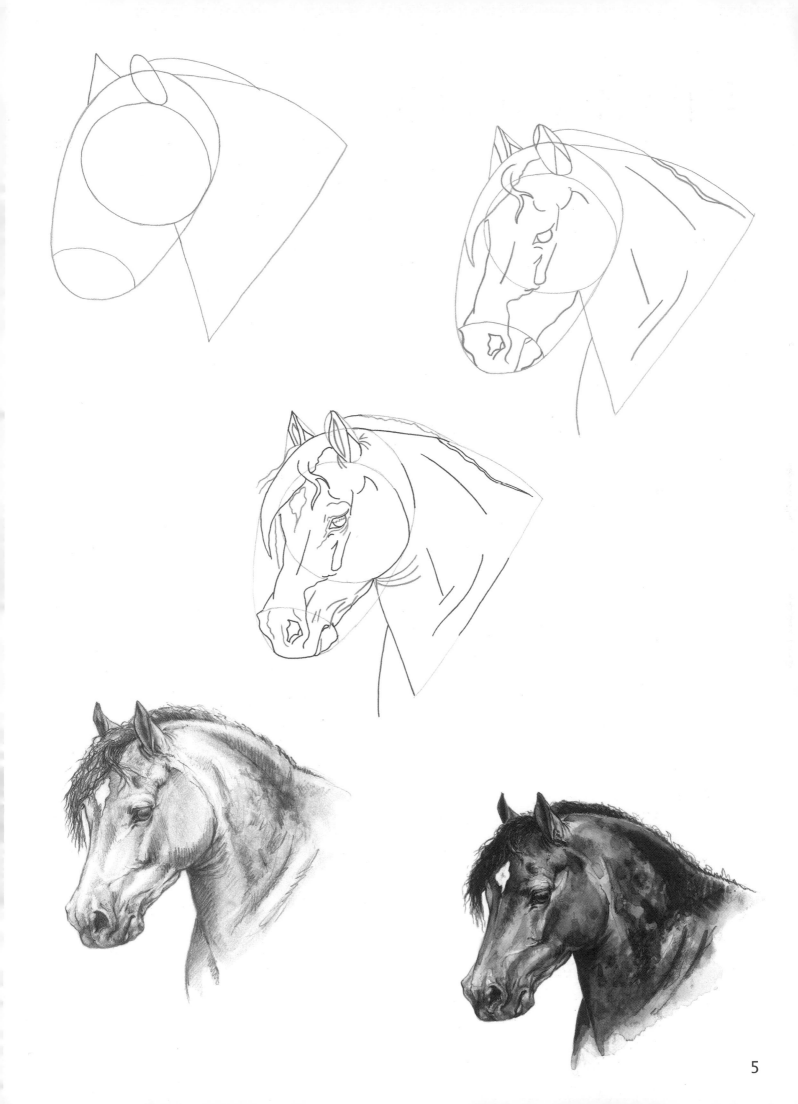

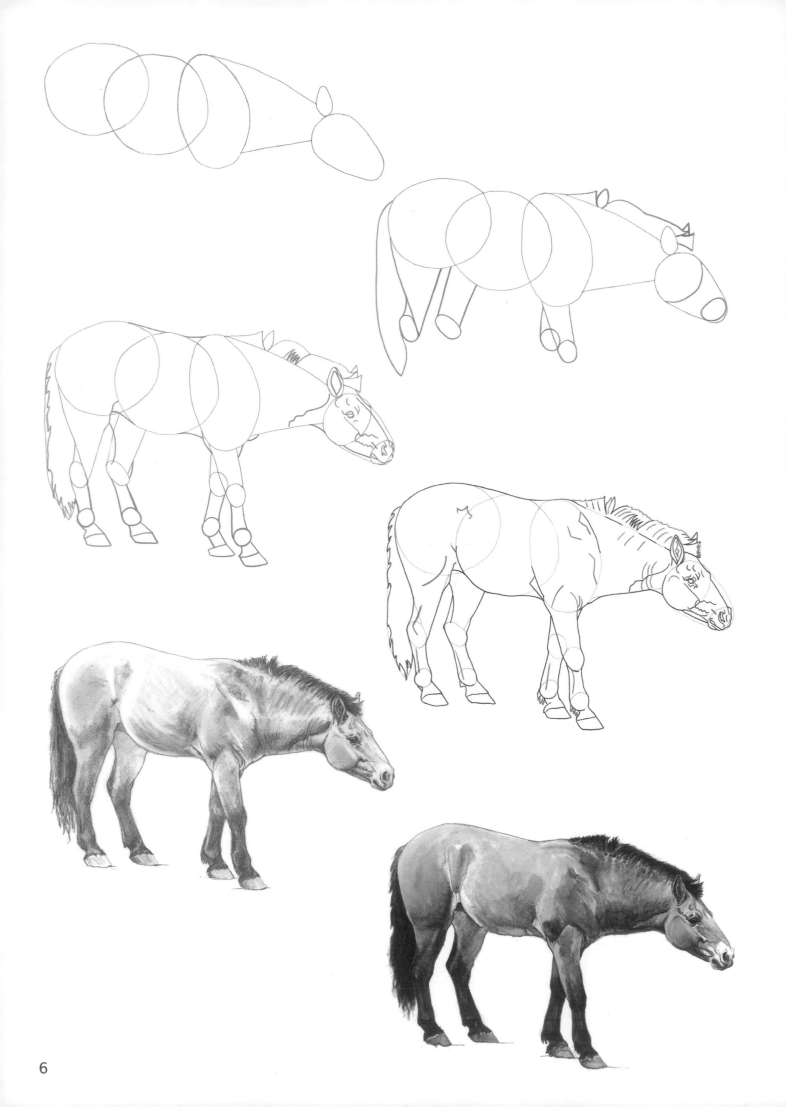

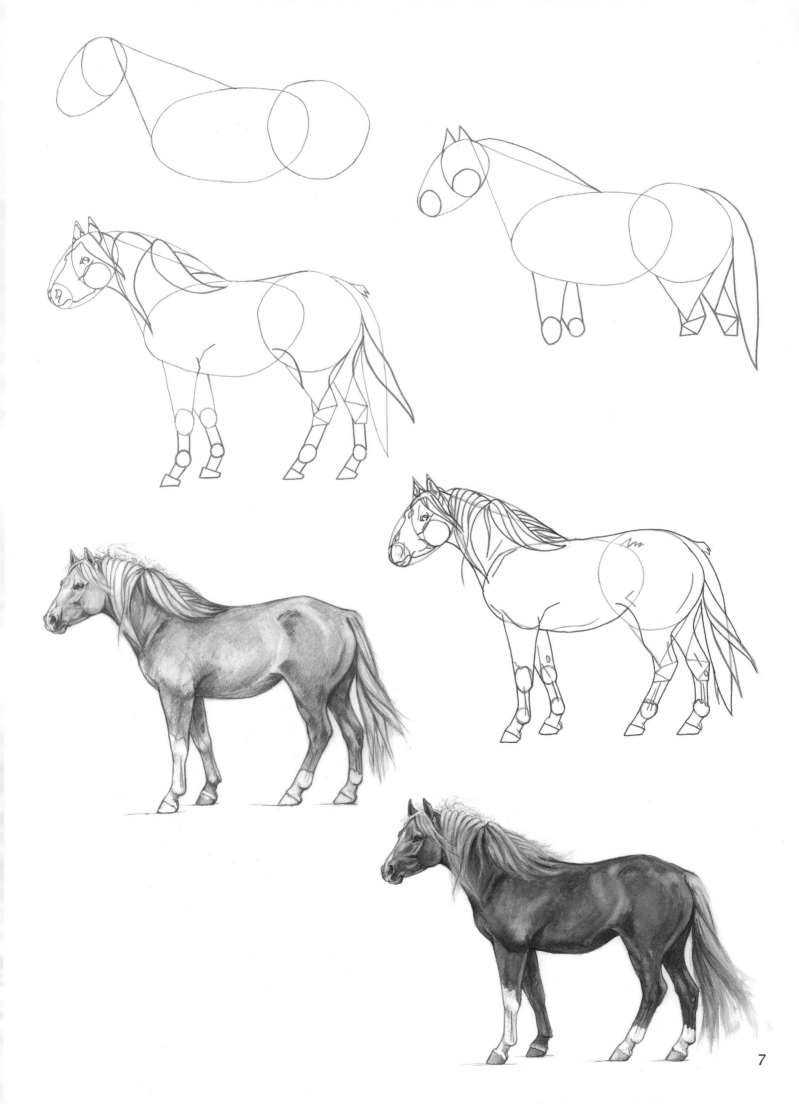

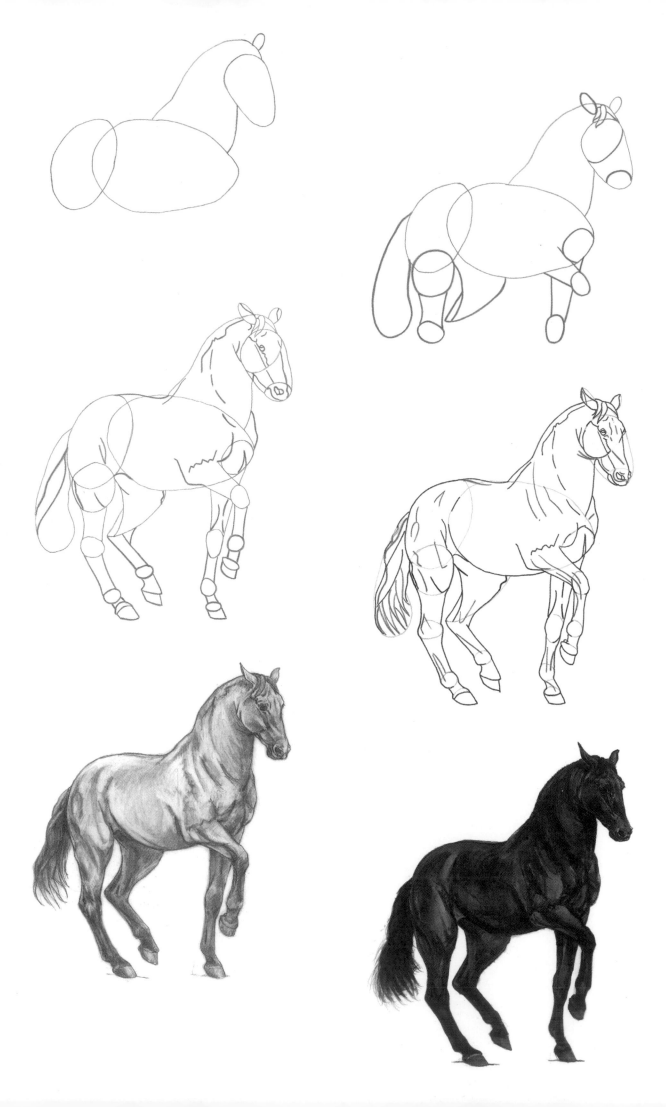

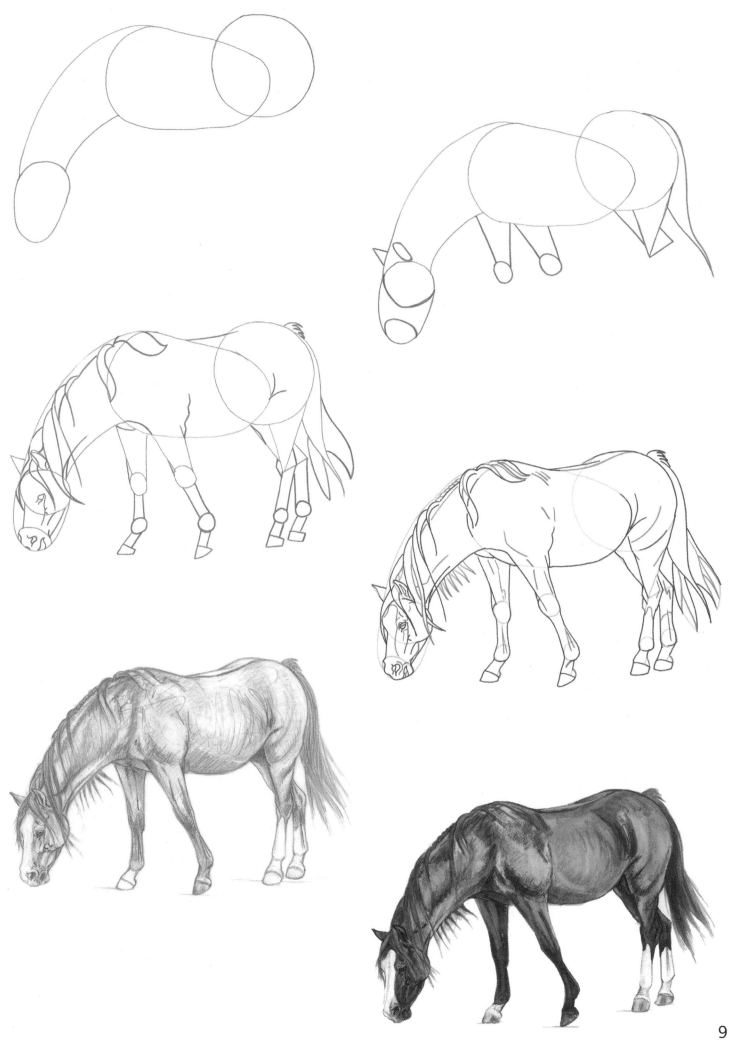

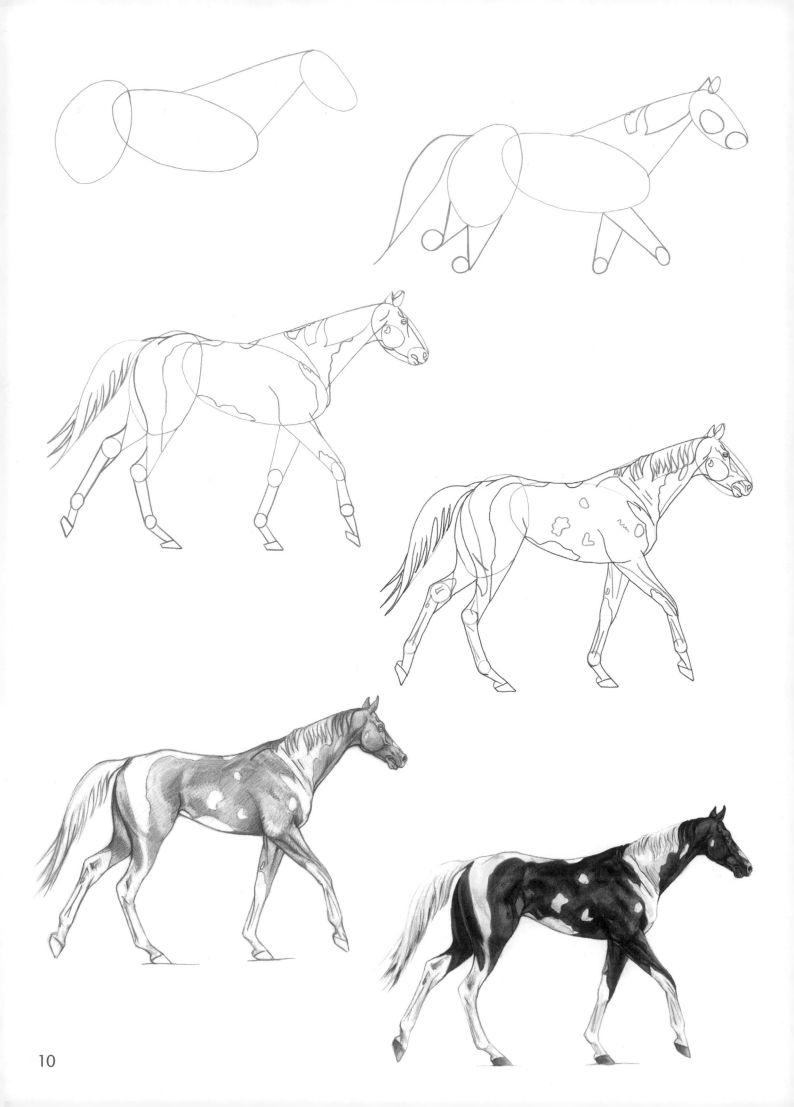

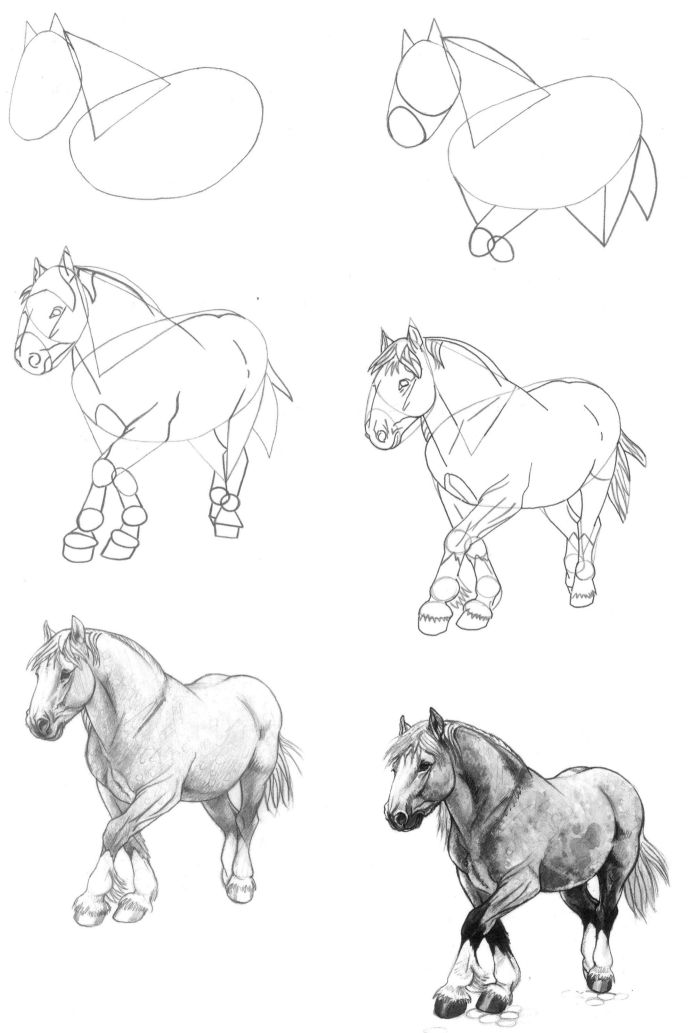

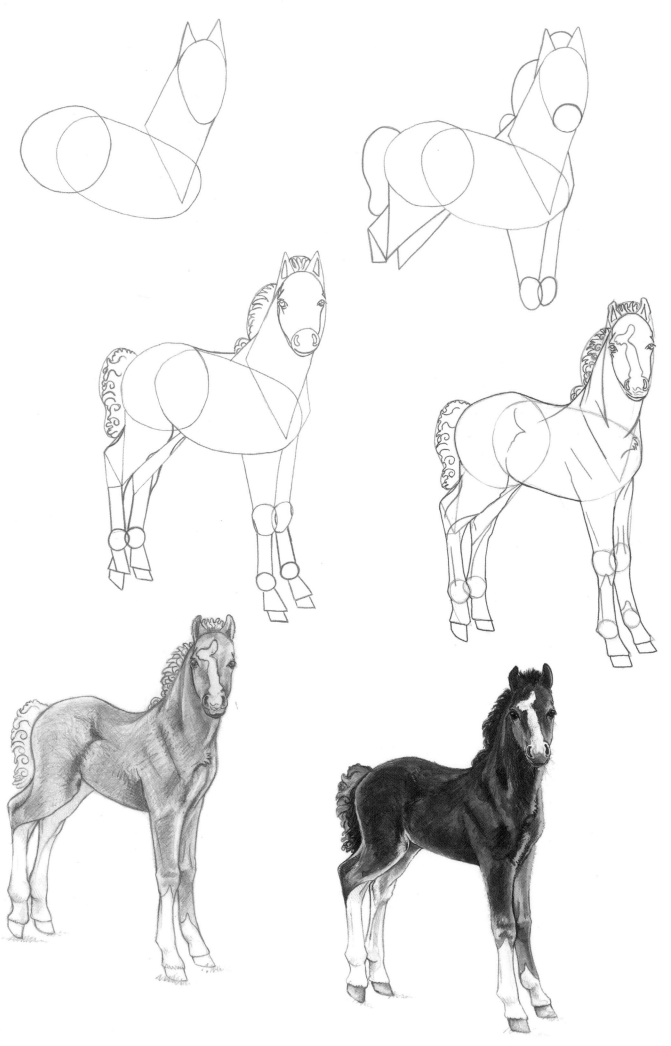

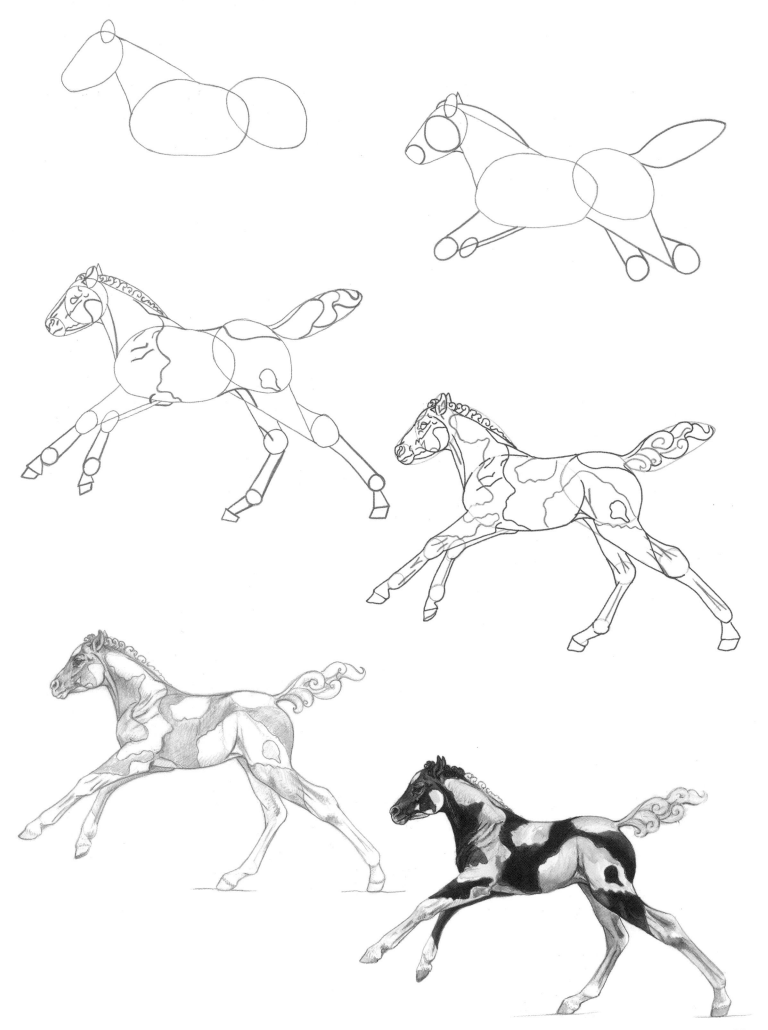

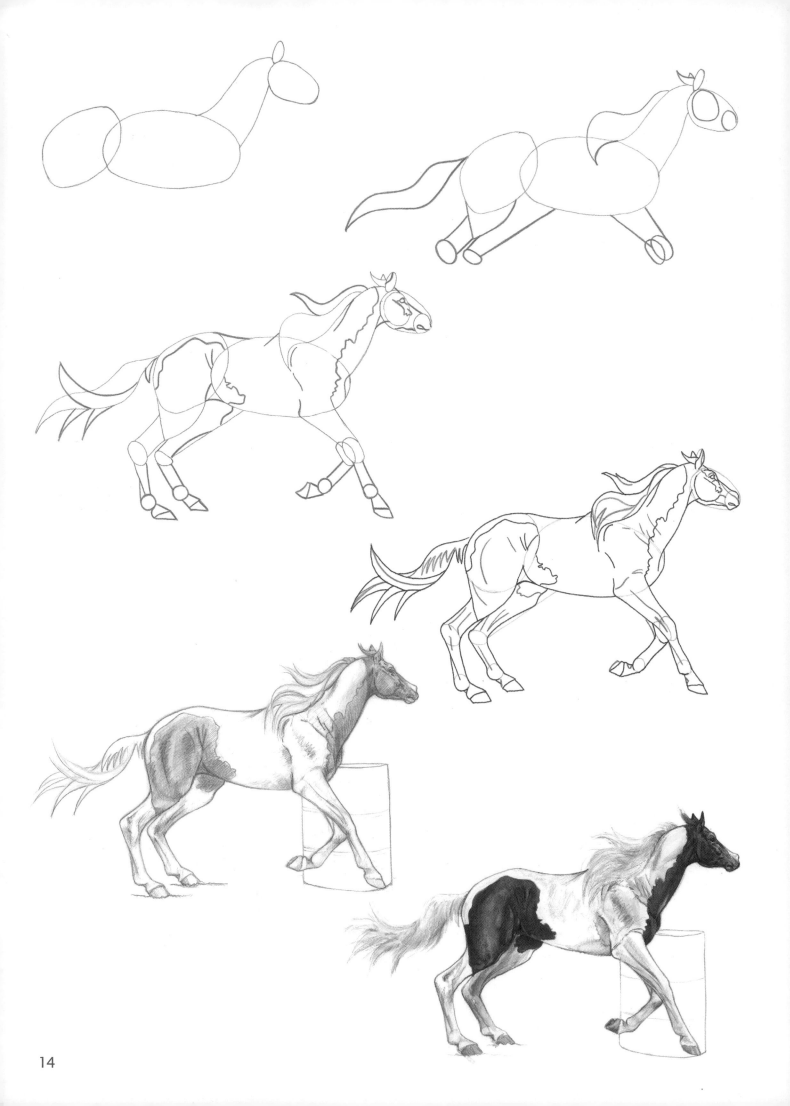

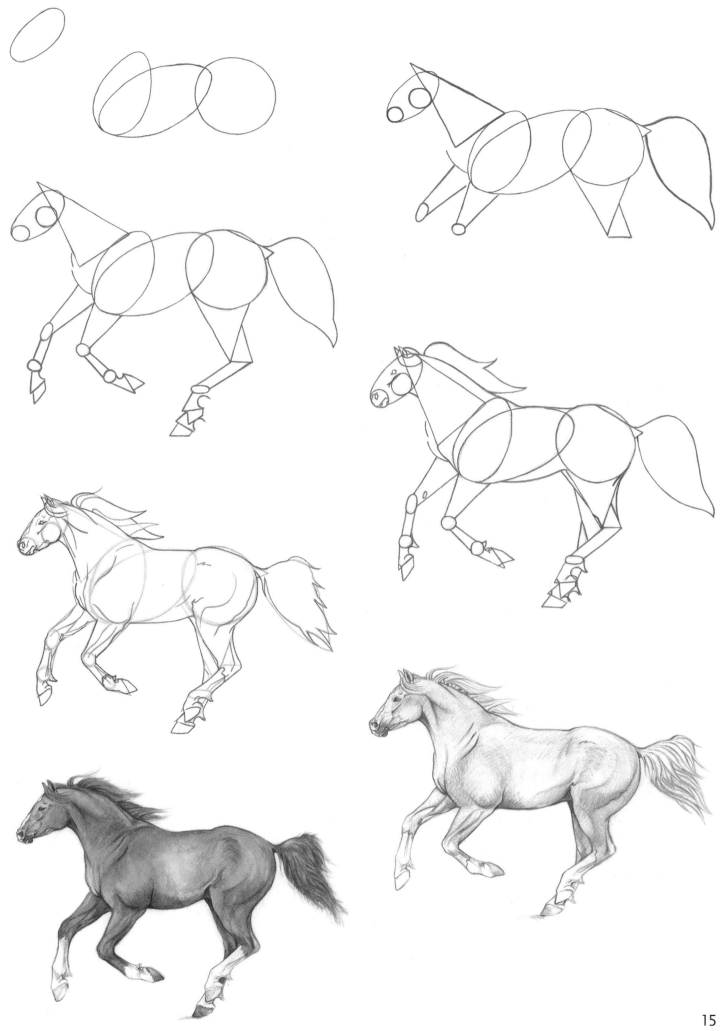

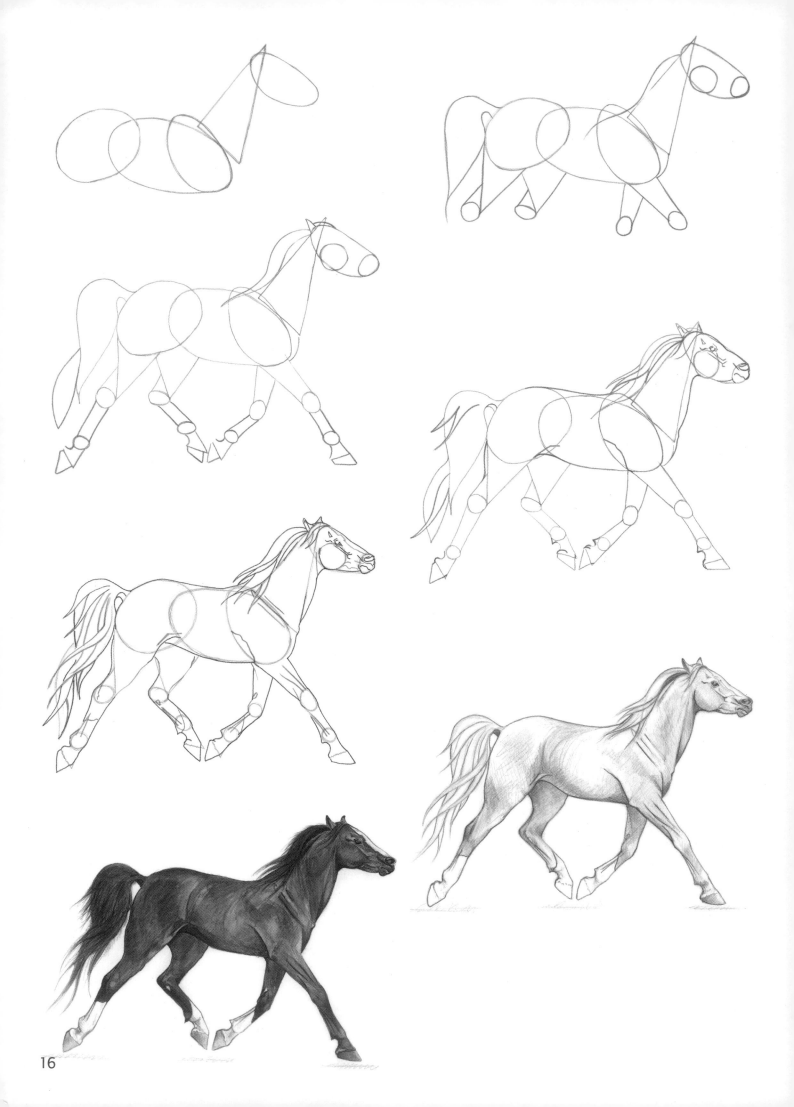

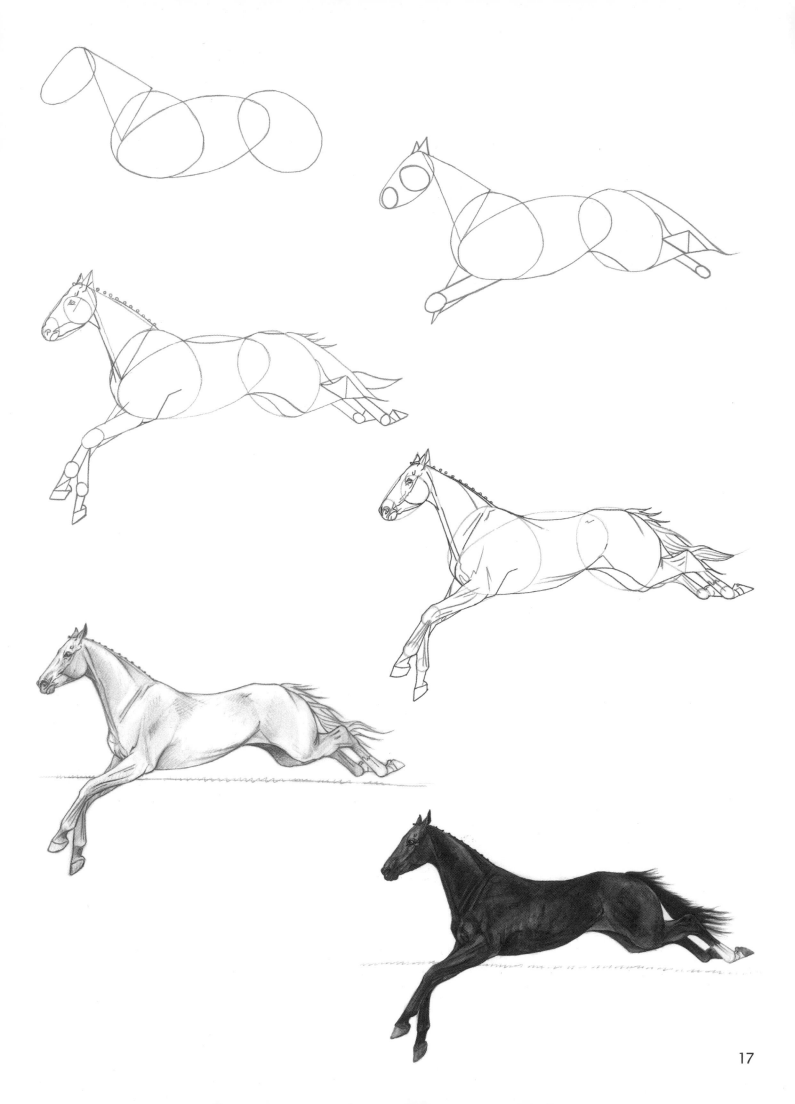

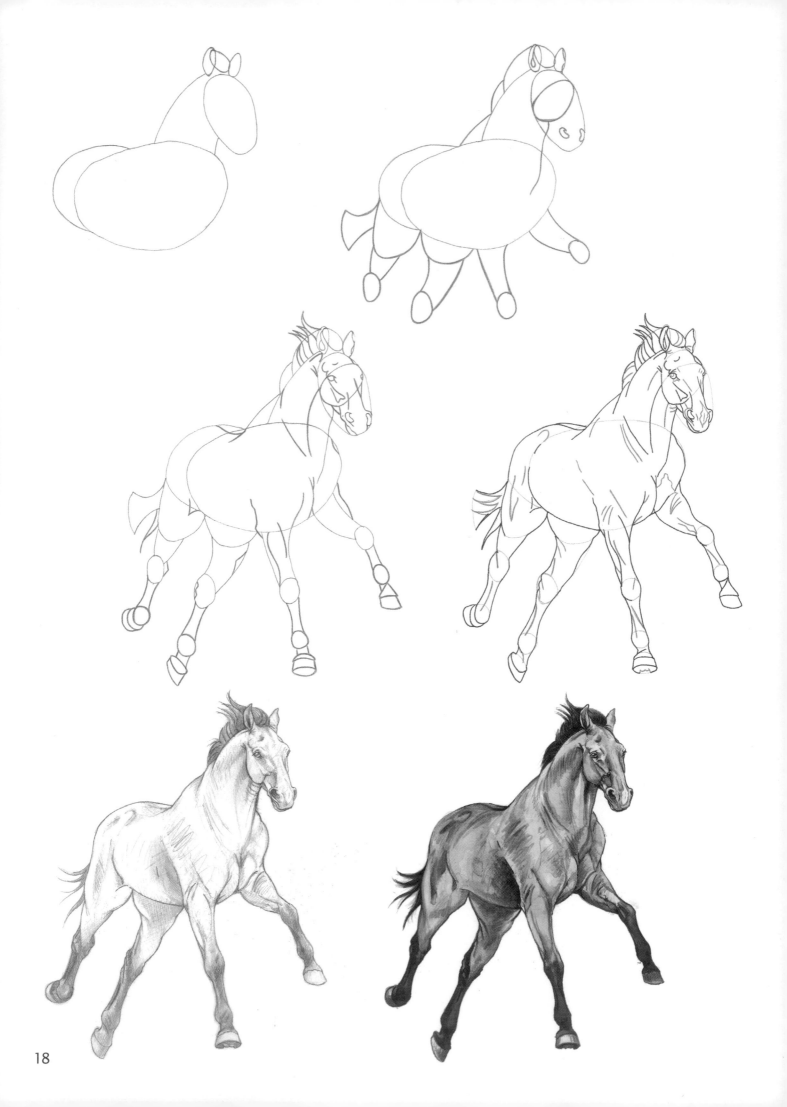

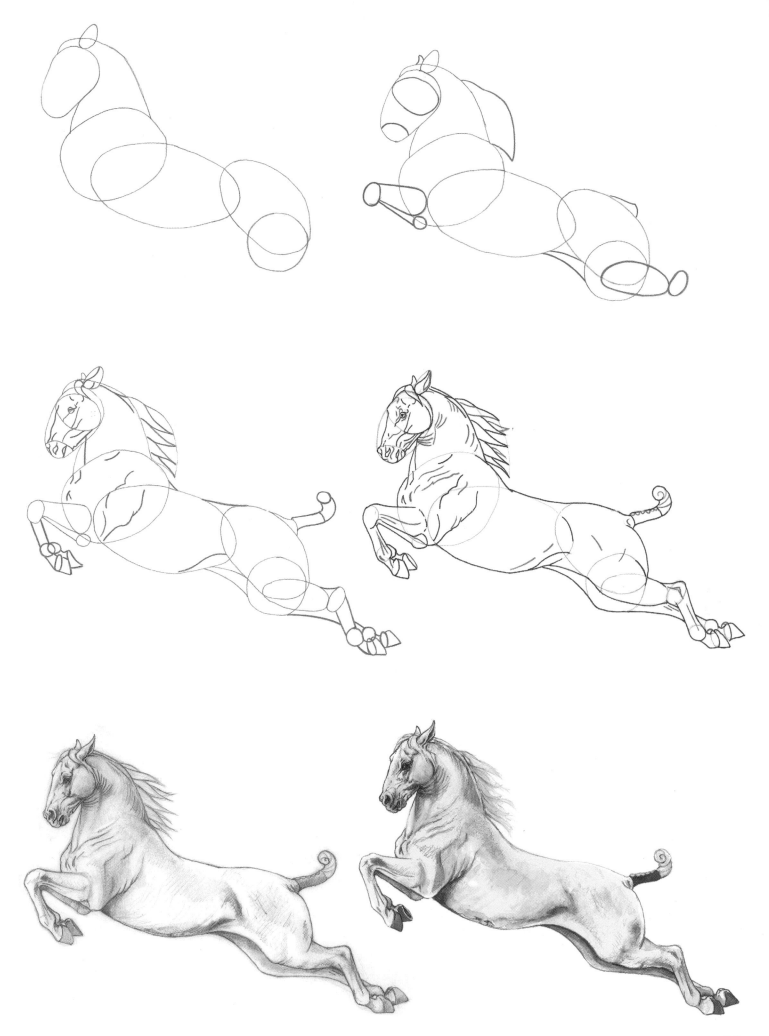

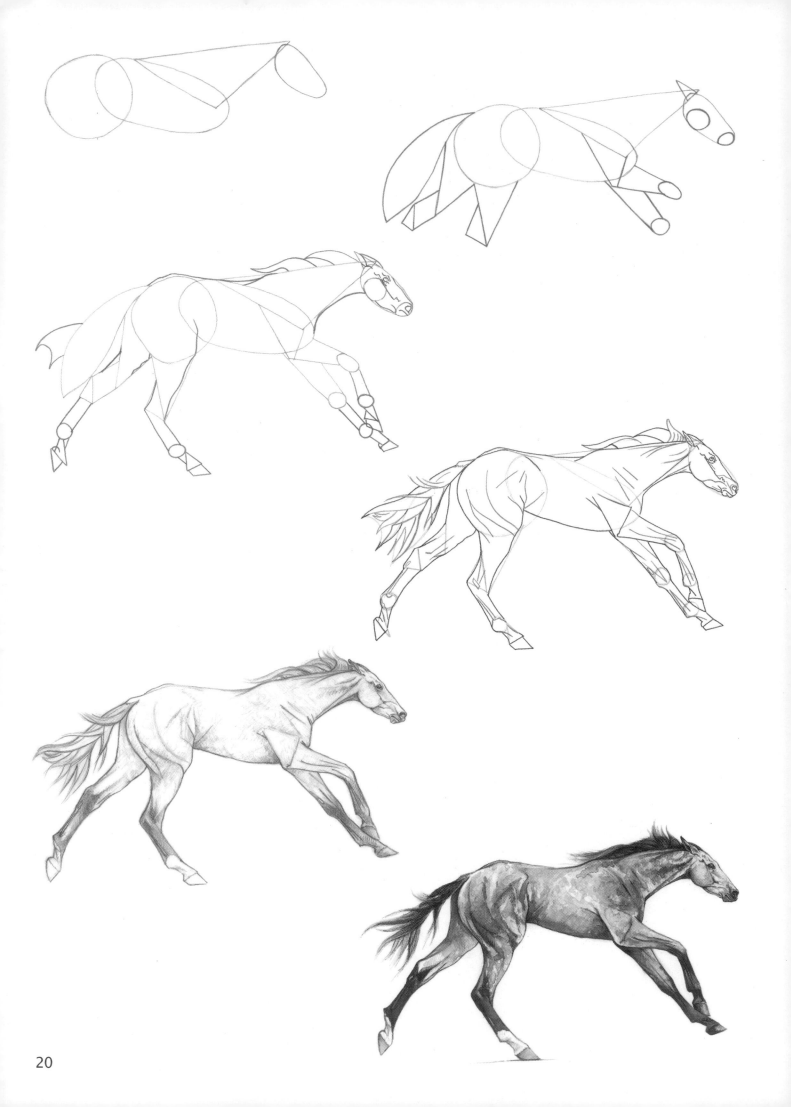

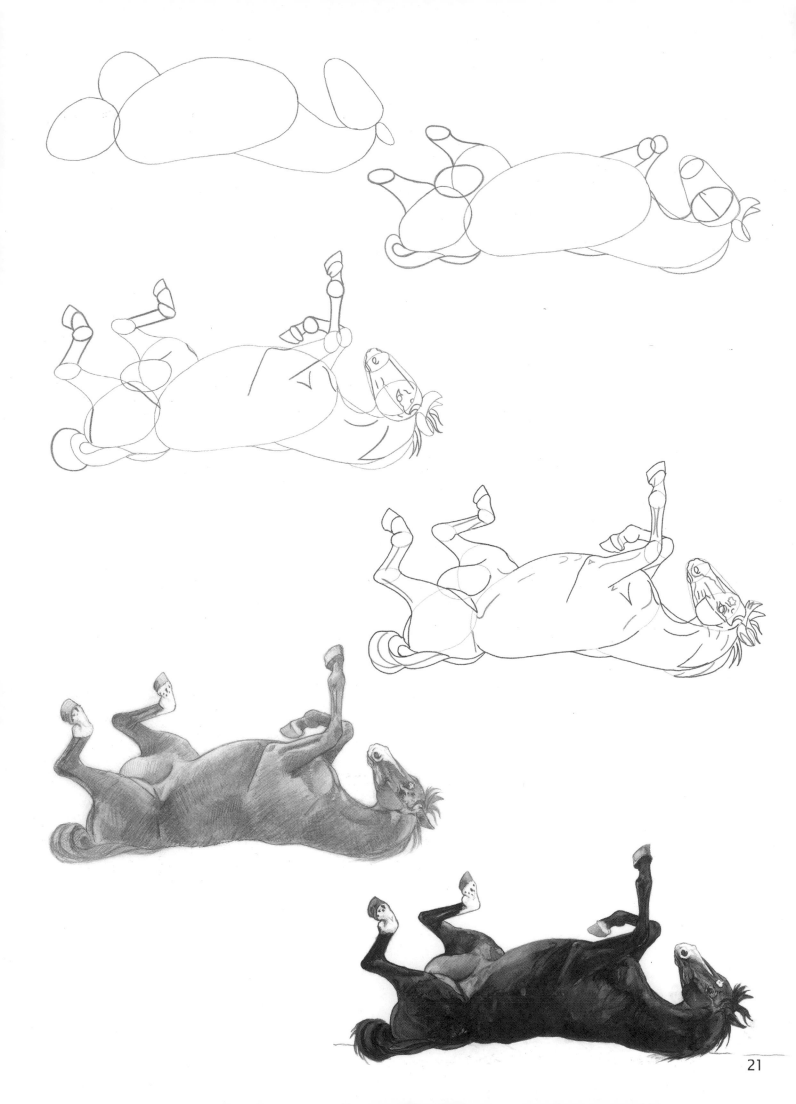

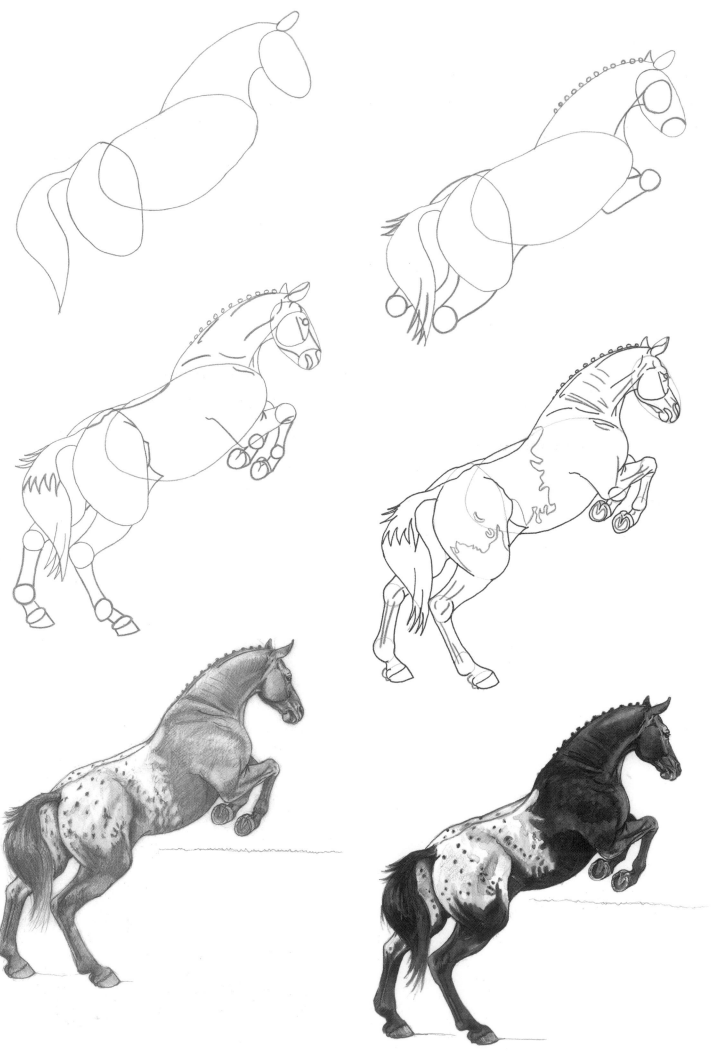

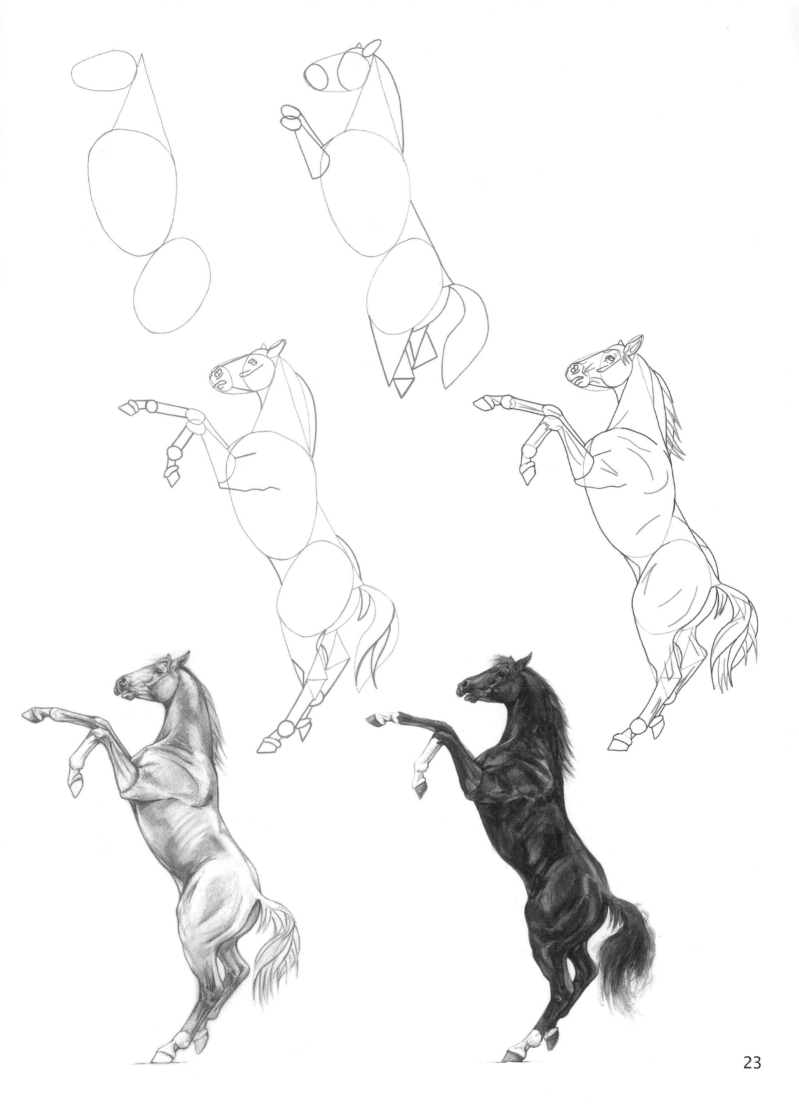

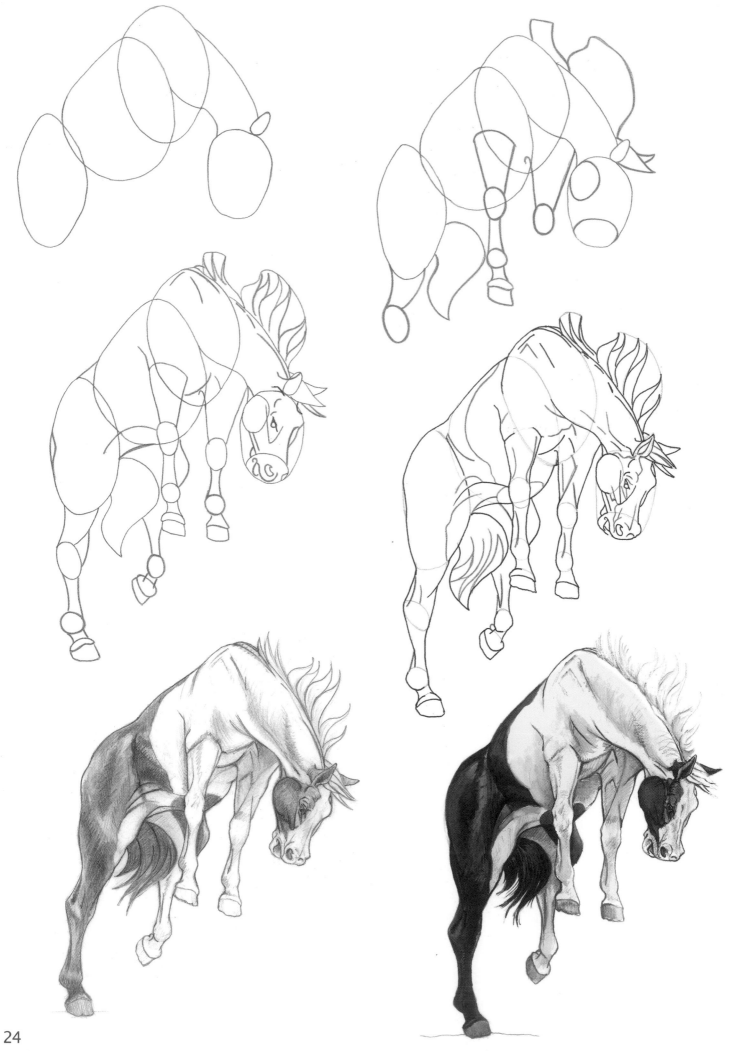

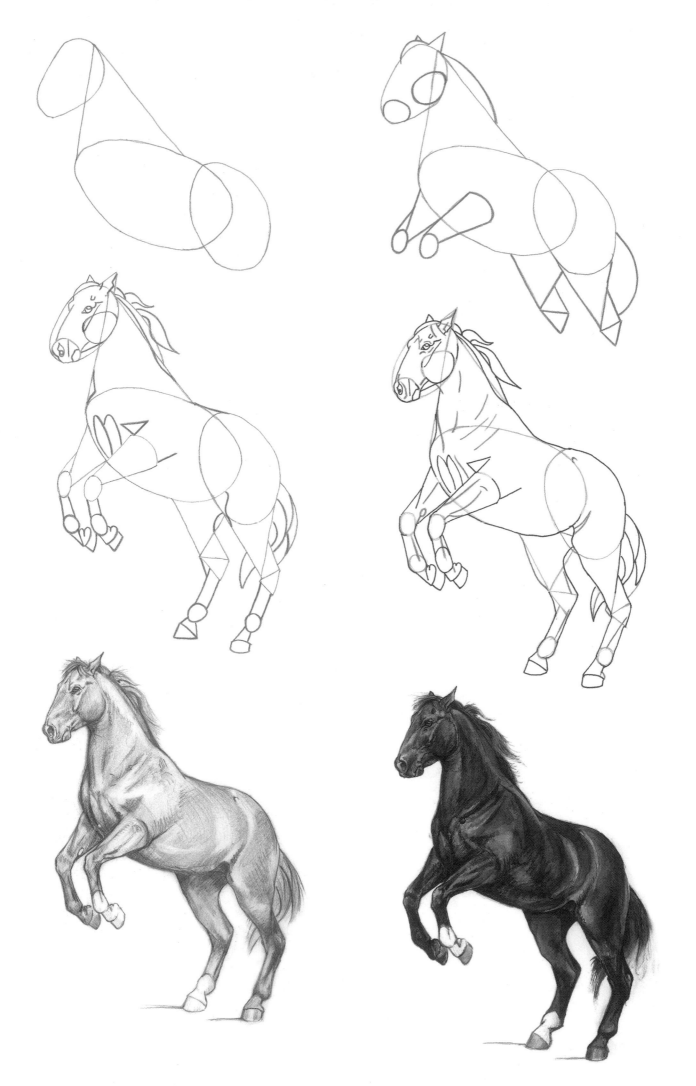

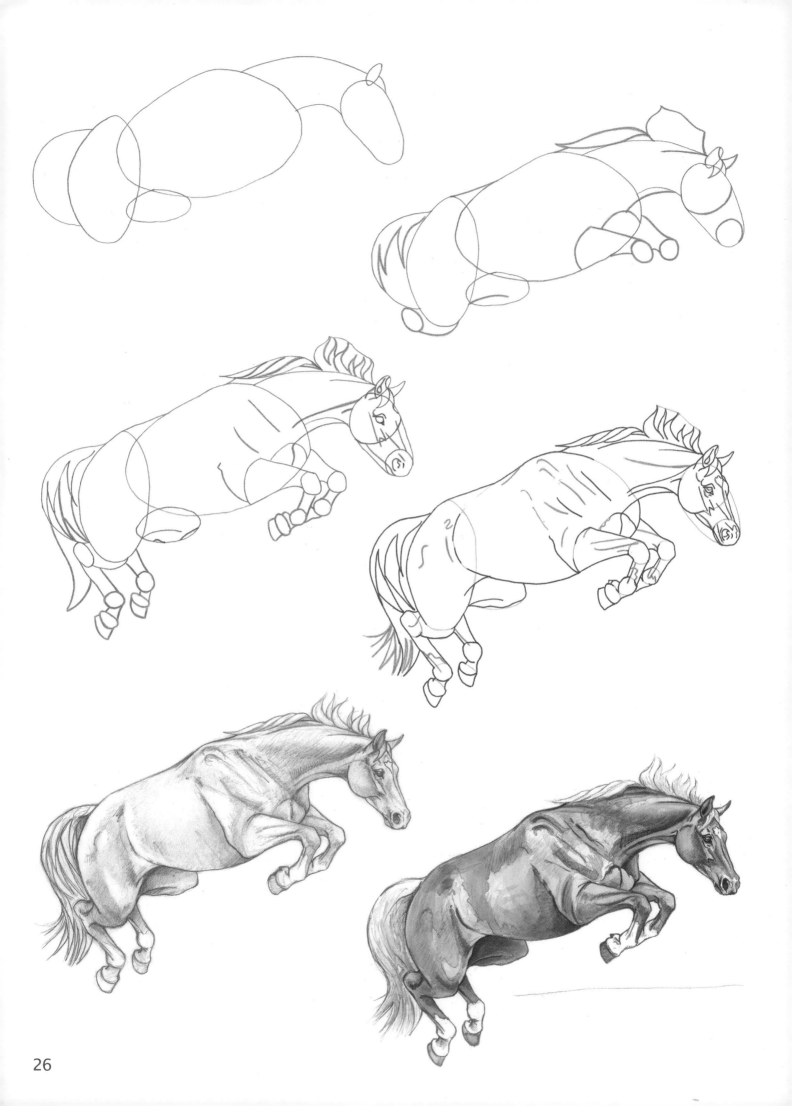

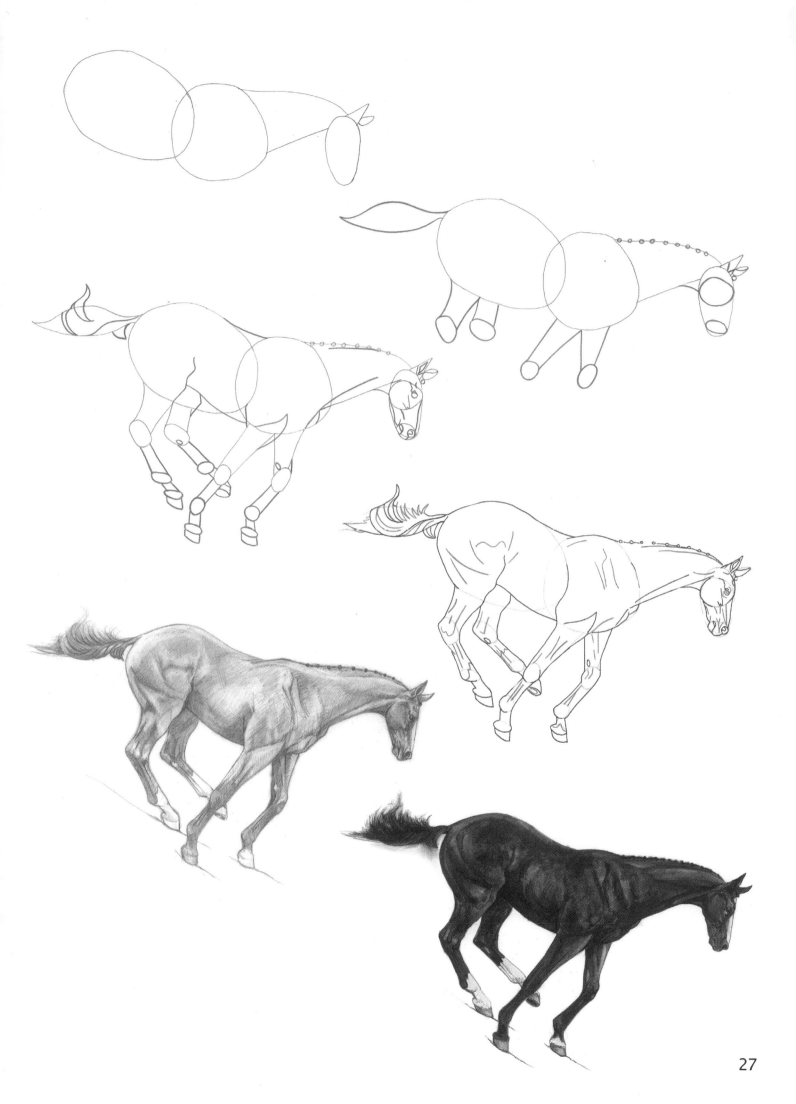

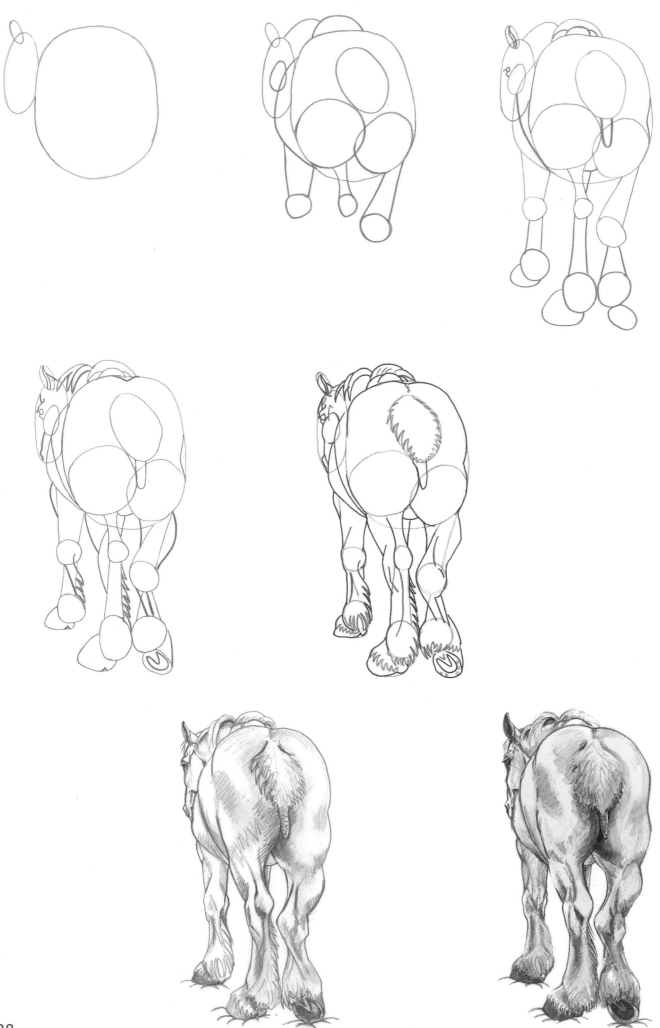

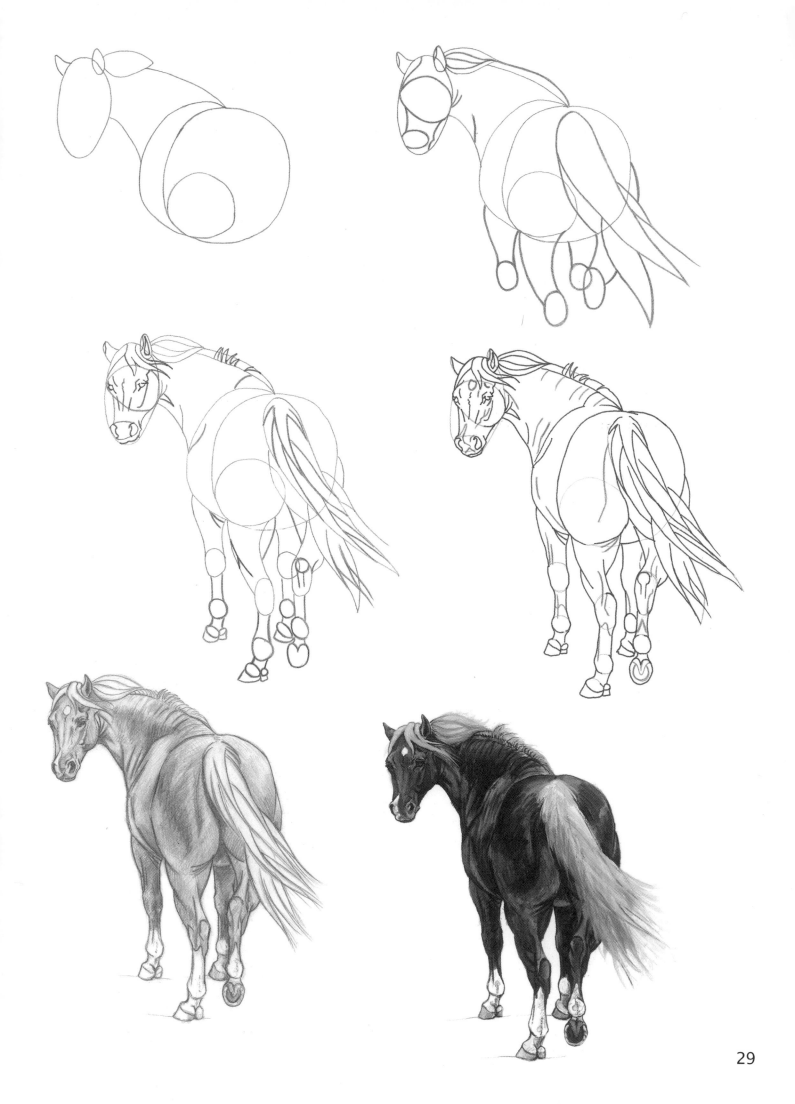

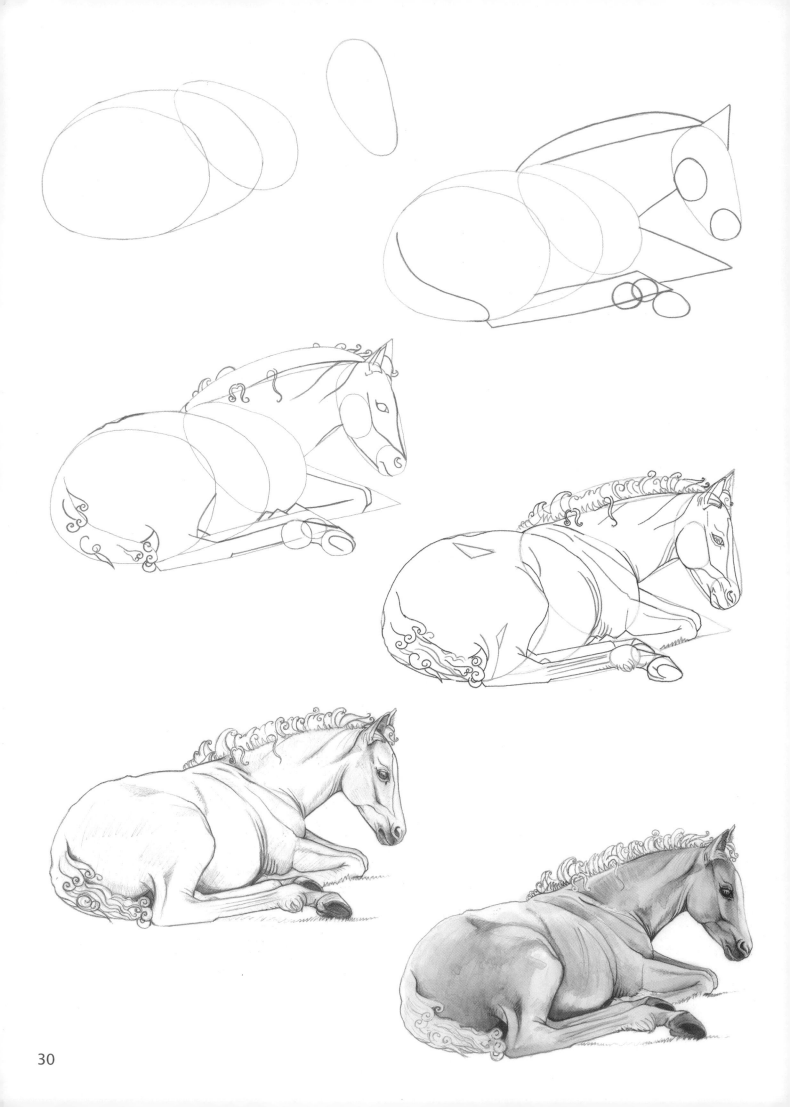

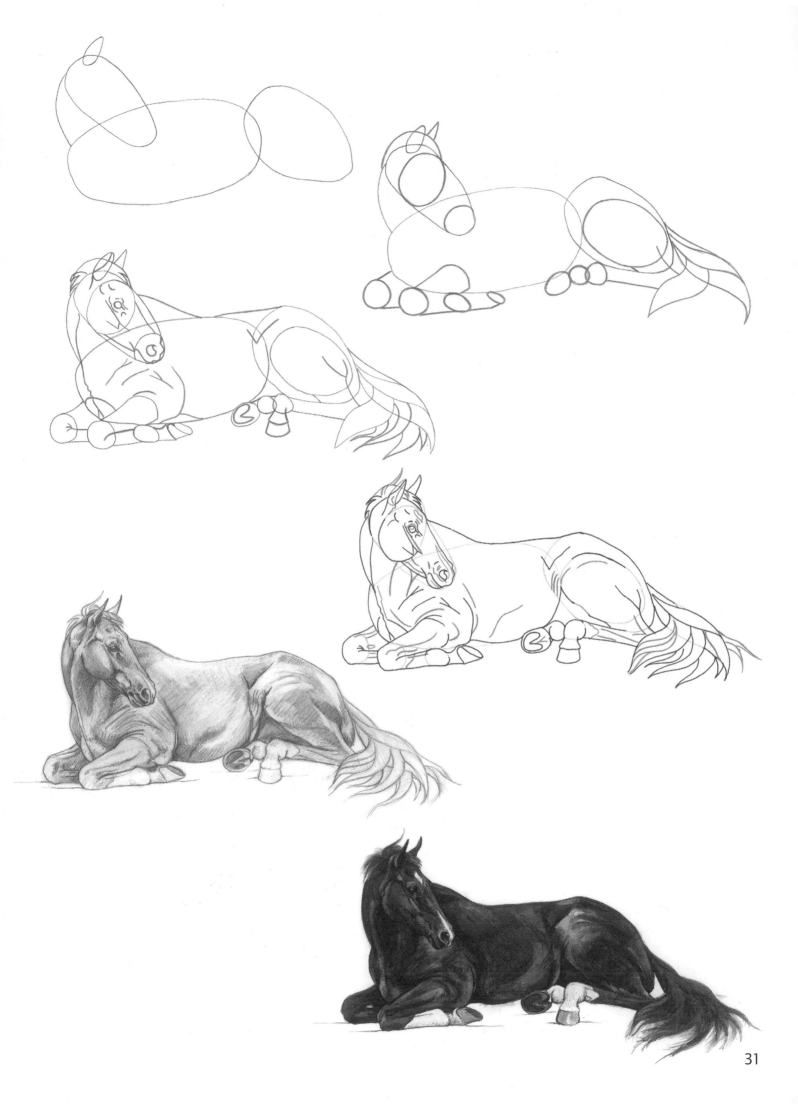

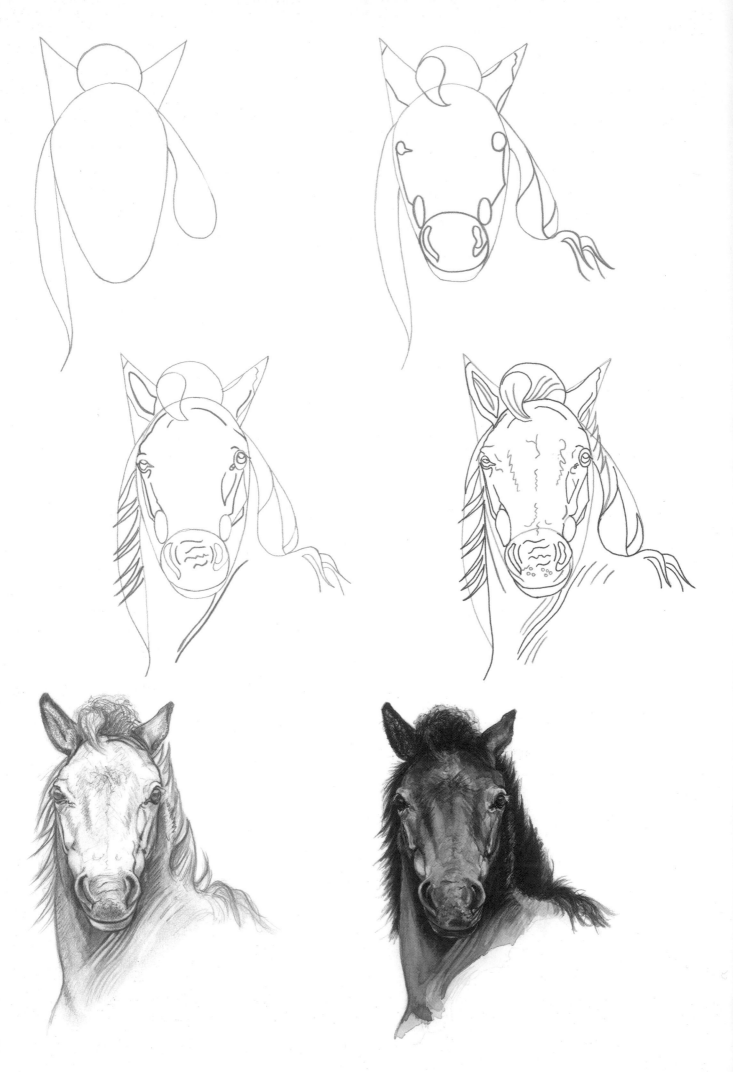